TELL ME ABOUT ARTISTS

LEONARDO DA VINCI

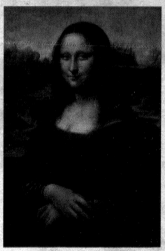

written by
John Malam

Evans

Evans Brothers Limited

Published by Evans Brothers Limited
2A Portman Mansions
Chiltern Street
London W1M 1LE

© Evans Brothers Limited 1998

First published 1998

Printed by Graficas Reunidas SA, Spain

British Library Cataloguing in Publication data.

Malam, John
 Leonardo da Vinci. - (Tell me about artists)
 1.Leonardo, da Vinci, 1452-1519 - Juvenile literature
 2.Painters - Italy - Biography - Juvenile literature
 3.Painting, Italian - Juvenile literature 4.Painting,
 Renaissance - Juvenile literature
I.Title
759.5

ISBN 0237518074

Leonardo da Vinci lived in Italy more than 500 years ago. He was one of the cleverest men of his time. He was an artist, and a sculptor. He drew fantastic machines to fly in the air and sail in the sea, and he discovered many things about how the human body works. This is Leonardo's incredible story.

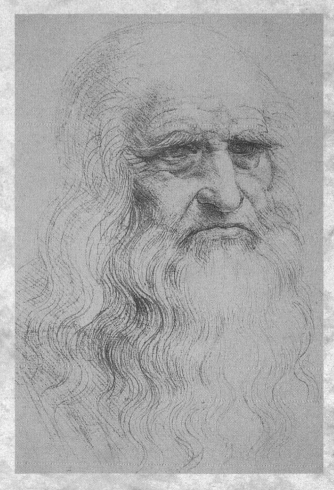

Leonardo made this drawing of himself when he was aged about sixty.

Leonardo da Vinci was born on the 15 April, 1452. He was born in the little mountain village of Vinci, in the north of Italy. His name means 'Leonardo of Vinci'.

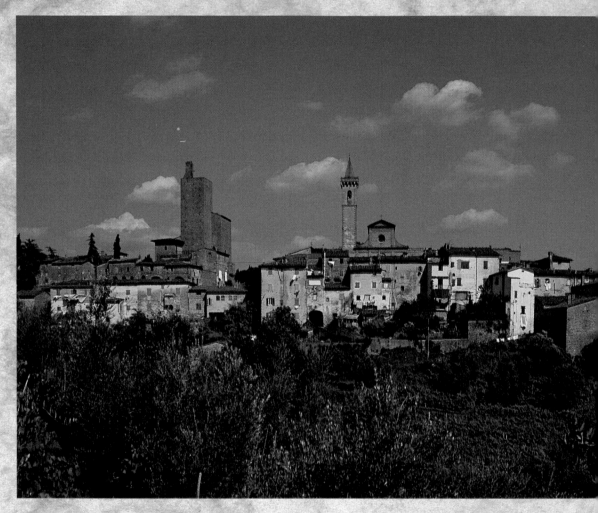

The village of Vinci where Leonardo was born

Leonardo's parents were not married, and he was sent to live with his grandparents. No one knows if his mother ever saw her son again.

After a time, Leonardo's father married a lady from a rich family. When Leonardo was five years old, he went to live with his father and stepmother.

Vinci is in a part of Italy called Tuscany, where grapes, olives, and vegetables are grown.

From an early age, Leonardo showed great skill as an artist. It is said that the young Leonardo painted a picture of a dragon that was so realistic it scared his father!

When Leonardo was seventeen, his father took him to the city of Florence, to meet Andrea del Verrocchio, who was a well-known artist. Verrocchio agreed to teach Leonardo about painting.

The city of Florence was home to many artists. It was one day's ride on horseback from Vinci.

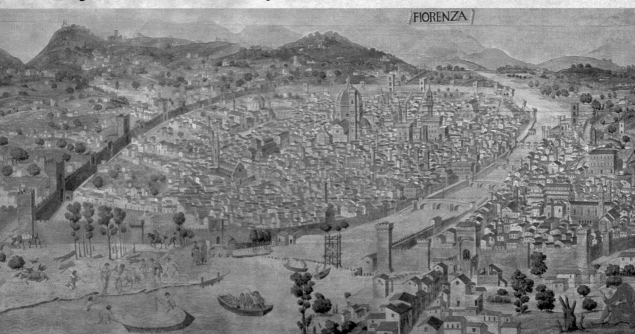

FIORENZA

When Leonardo was about twenty years old, Verrocchio gave him an important job to do. Lying in a corner of the workshop was a painting his teacher had started, but not finished. It was a painting of John the Baptist baptising Jesus Christ. It needed an angel painting on the left side of the picture.

Leonardo painted the angel using oil paints, which were a new invention. The angel shone with colour and light.

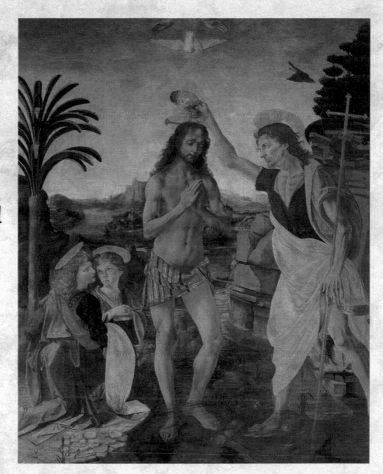

The 'Baptism of Christ', painted by Verrocchio. The kneeling angel on the lefthand side was painted by Leonardo.

Before Leonardo, most artists painted either religious scenes or pictures of important people. Leonardo wanted to be different. He was interested in nature, and so he began to make drawings of the countryside.

Leonardo lived near the River Arno. He made a drawing of it in pen and ink. His picture was full of the feeling of moving water, and shadows cast by the trees.

The River Arno today

Leonardo's drawing of the valley of the River Arno

10

When Leonardo was thirty, he left Florence and went to work for the Duke of Milan. The Duke was powerful, and Milan was a great city.

The Duke asked Leonardo to make a bronze statue of his father on horseback. Leonardo said he would make the biggest horse statue of all time – 6.7 metres tall! But the statue was never made.

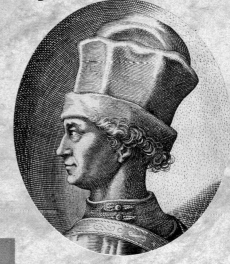

The Duke of Milan, Ludovico Sforza, who asked Leonardo to work for him

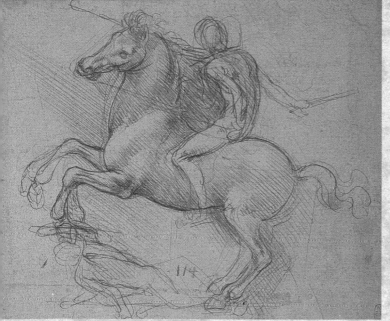

Leonardo made this sketch of the horse statue in 1488.

During his years in Milan, Leonardo felt unhappy about his work. What he really wanted to do was work as an inventor, not as an artist. He wanted to help the Duke in his wars against France and Spain.

Leonardo wrote a letter to the Duke, asking to work as a designer of weapons. He said he could also build a bridge that could be lifted up and down, like a drawbridge.

But the Duke did not want Leonardo to work as an inventor. He wanted him to work as a painter. The Duke wanted to make Milan into a beautiful city, like Florence, and he wanted Leonardo to make his wish come true.

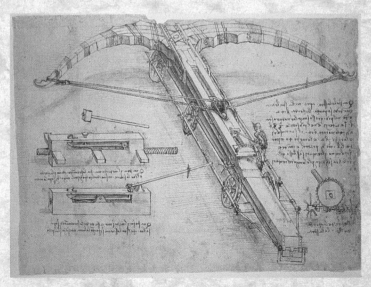

Leonardo sketched this giant crossbow in his notebook. If it had ever been made, it would have been 26 metres long.

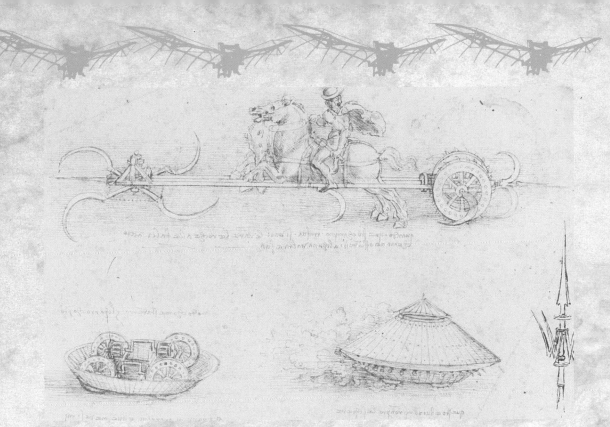

The notes and sketches Leonardo made tell us about his ideas, and what he was thinking.

Leonardo's ideas for inventions were not made into real machines in his own lifetime. It was only after he died that people who read his notebooks realised that some of his inventions would work. They made models to prove it.

This gun was built long after Leonardo's death. It shows that his designs worked.

While Leonardo was in Milan he painted one of the world's great paintings. In a church, on the wall of the monks' dining-room, he painted 'The Last Supper'. It shows Jesus Christ and the apostles eating their last meal together.

Leonardo spent two years on the painting. The monks thought that was far too long!

Leonardo's 'The Last Supper'. You can see how some paint has flaked off. There are cracks in the wall, too.

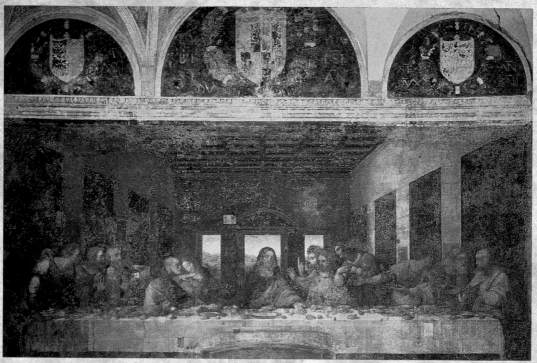

After eighteen years in Milan, Leonardo returned to Florence. It was here that he painted his most famous picture.

A wealthy merchant from Florence asked Leonardo to paint a portrait of his young wife. Her name was Mona Lisa. Her portrait became one of Leonardo's favourite paintings. Instead of letting the merchant have it, Leonardo kept it! Today it hangs in the Louvre Museum in Paris.

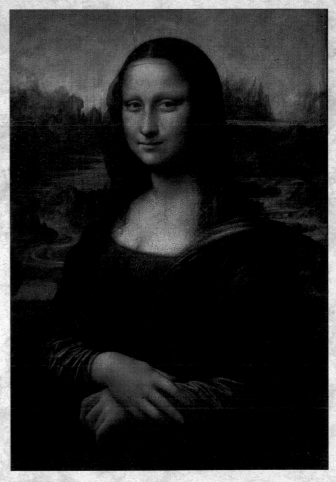

Many things make the 'Mona Lisa' a great painting. Her eyes have a thoughtful, faraway look, and her mouth has the faintest of smiles.

Leonardo's genius as an inventor can be seen in his ideas for flying machines. He studied birds and bats and made drawings of their wings and how they worked. This gave him the idea for a machine that looked like a giant wing, powered by a man pedalling underneath it.

Leonardo's sketch of his man-powered flying machine.

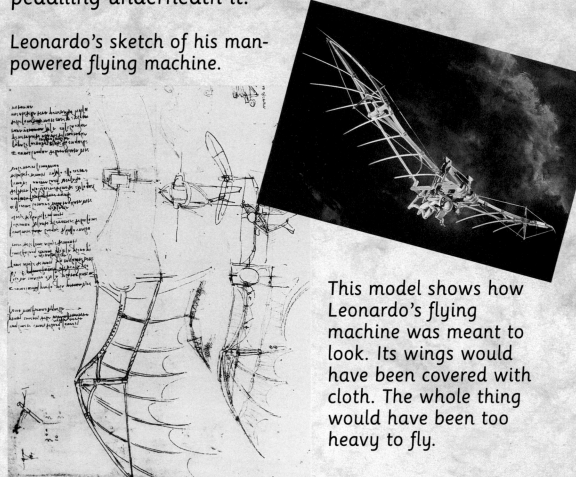

This model shows how Leonardo's flying machine was meant to look. Its wings would have been covered with cloth. The whole thing would have been too heavy to fly.

In his later years, Leonardo was persuaded to return to Milan, where he was asked to paint pictures for King Louis XII of France.

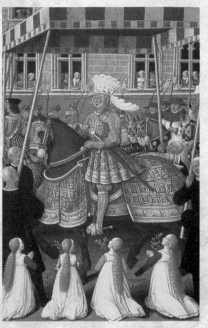

Another artist painted this picture of King Louis XII of France

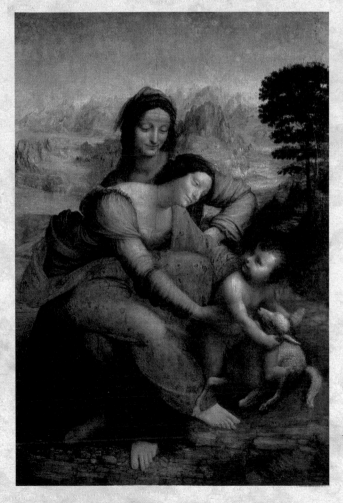

Leonardo's 'Virgin and Child with St Anne'

As Leonardo grew older, he became more and more interested in the human body. He cut up many dead bodies and made detailed drawings of their working parts. He wanted to find out how the heart, brain, eyes, arms, legs, and muscles worked. He wanted to study the body through all its stages, from birth until death.

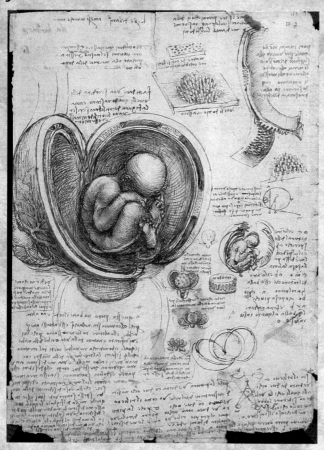

Leonardo's drawing of a baby in its mother's womb.

►Leonardo began some paintings by making full-size drawings of them in charcoal.

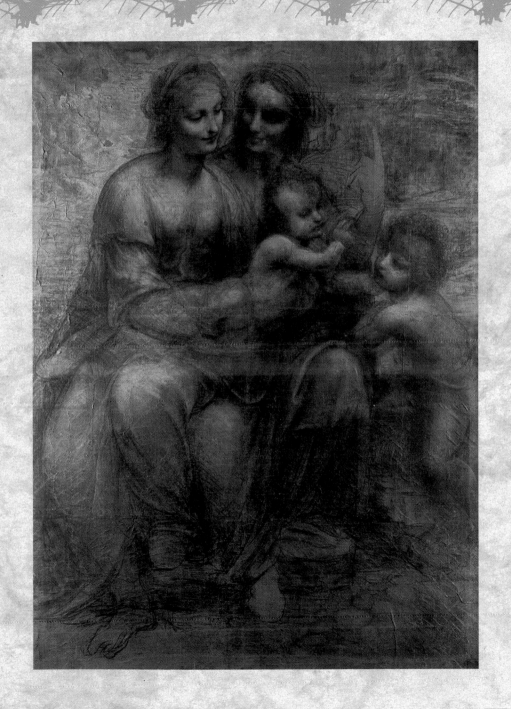

When Leonardo was an old man, the new king of France asked Leonardo to come and live in France and make paintings for the royal household.

Leonardo lived in France for the last two years of his life, where he continued to write notes, make drawings and conduct experiments. When he died in 1519, at the age of 67, he left behind more than 5,000 pages of notes and drawings, and some of the most beautiful paintings the world has ever seen.

The house in France where Leonardo lived

Leonardo's bedroom

Important dates

1452 Leonardo was born in Vinci, northern Italy

1467 He joined the workshop of Andrea del Verrocchio, in Florence

1473 His drawing, 'The Valley of the Arno', shows his interest in the landscape

1482 He moved to Milan, to work for Duke Ludovico Sforza

1488 He first wrote about machines that can fly

1489 He began to study the human body

1490 He started work on a giant bronze statue of a horse

1497 He finished painting 'The Last Supper'

1499 The French arrived in Milan, and Leonardo left

1503 He returned to Florence

1504 His father died

1507 He finished painting the 'Mona Lisa'

1509 He returned to Milan, where he made detailed drawings of the human body

1510 He finished painting the 'Virgin and Child with St Anne'

1516 He moved to France

1519 Leonardo died in France, aged 67

Leonardo was left-handed. He wrote from right to left and back to front. This meant he did not smudge the ink as his hand moved across the page.

Keywords

artist
someone who makes drawings and pictures

charcoal
partly burned wood used for drawing

oil paint
a type of sticky paint, made by mixing a colour with oil from a plant

portrait
a picture of a person

sculptor
someone who carves figures out of stone

sketch
a rough drawing, made quickly

Index